gottex ®

Swimwear Haute Couture

© 2006 Éditions Assouline
26-28, rue Danielle-Casanova, 75002 Paris France
Tél. : 01 42 60 33 84 Fax : 01 42 60 33 85
www.assouline.com

Translated from French by Paul Jones

ISBN: 2 84323 872 2

Color separation: Gravor (Switzerland)
Printed by Grafiche Milani (Italy)

HÉLÈNE SCHOUMANN

gottex ®

Swimwear Haute Couture

ASSOULINE

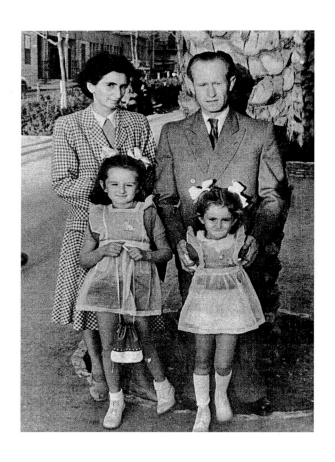

Lea and Armin Gottlieb and their daughters Miriam and Yehudit, 1948.

Princess Diana in a leopard skin printed swimsuit, on a deck of a yacht. Queen Sofia of Spain leisurely wearing a classic textured swimsuit, in the privacy of her resort home in Palma de Majorca. Shirley MacLaine vamping it up in a black bustier and stiletto heels in *Vanity Fair*. Naomi Campbell, superbly feline in a red-flame piece with long sleeves and pearl a waistband. Angelina Jolie in a vintage white swimsuit, posing statuesquely next to Brad Pitt on the cover of *W* magazine. In each of these photos, published around the world, the star is wearing a Gottex swimsuit.

Over the past five decades, the Israeli brand has secured its status as the Rolls-Royce of swimsuits. Boldness and glamour are the guiding values of the label with the famous monogram, whose designs have become must-have items in the wardrobe of every refined and elegant woman.

Paradoxically, you would almost think twice about actually bathing in a Gottex swimsuit: they are primarily intended for relaxing by the pool, tanning on the rear deck of a yacht, or sipping a cocktail in a Saint-Tropez beach bar.

In the 1960s, foretelling the trend, the brand was the first in the world to launch the art of beach living, offering accessories and coordinates to match its swimwear. Drawing its inspiration from marine flora and fauna, Gottex created collections of clothing perfectly suited to the seaside and to lavish resorts: long embroidered skirts, broad-fitting trousers, small sexy bustiers, tunics and caftans that are easily slipped on after bathing. Each style was conceived and developed as a unique design: in the search for prints, matching shades, pleats and couture finishes, nothing was left to chance when designing its collections.

In its constant research for aesthetic perfection, the brand has always given priority to creative design and an innovative concept of sensual comfort. A very personal sense of detail makes each item a piece of luxury and refinement and lends Gottex a haute couture image.

this success story stems first from the audacity of one woman, Lea Gottlieb, who was a true visionary. Lea Gottlieb was born in 1918 in Hungary, and studied biochemistry. In those days, Budapest was effectively a province of Vienna, the cultural hub of Europe. People would travel there to attend a concert or visit an art exhibition: Kokoshka, Klimt and Schiele set the tone and color with their visionary graphic art. As a young student, Lea soaked up all the artistic movements. She was passionate about art, and later drew inspiration from it when designing her swimsuits. She married Armin Gottlieb, who owned a raincoat factory. They both

survived World War II and left Hungary in 1949. They found their home in Israel and settled in a transit camp as many other Holocaust survivors did in those days. But the Gottliebs at first felt somewhat disoriented. How could they adapt their expertise to their host country? A quick analysis of her new homeland led Lea to forget about raincoats and create a concept adapted to the hot weather climate she so loved. Buying fabric with the proceeds from selling her wedding ring, Lea borrowed a sewing machine from a friend and went to work.

Struck by the rhythm of the new and young city, Tel Aviv, by its architecture inspired by the German Bauhaus movement, she had the idea of creating a swimsuit label for the women of this sun-drenched land. Gottex designs, she resolved, would be inspired by the light and contrasting colors of Israel: the aqua of the Mediterranean sea, the golden yellow of the desert, the blue of Lake Tiberias, the pink of Jerusalem's stone, and the many greens of Galilee. She dreamt up an idea that had occurred to no one else in this new country, introducing glamour with a brand of women's swim and beachwear designs.

Launched in 1956, the label was an instant success. Gottex gave women in Israel and elsewhere what they most needed: a new look, with swimwear styles that were innovative, sophisticated, freshly contemporary and superbly highlighting the female body. With Gottex, the swimsuit became an item of clothing in its own right, and in its wake came a series of accessories and coordinates. In 1996, in an issue of a fashion magazine, Lea Gottlieb confided: "I wanted to create a whole world that centered on the swimsuit. No brand had ever done it before, and that also helped make

Gottex original. Women can wear our collections from pool to bar, then go out to a restaurant or a cocktail party." Besides swimsuits, Gottex's collections features a host of caftans, tunics and trousers which provides a complete summer wardrobe.

So arresting were Gottex's colors and designs that they called to mind living paintings. In 1977, long before anyone else, the brand introduced ethnic styles, picking up the essence of the most beautiful African and Asian visual arts. This search for color and the constant need for new artistic stimulations brought Gottex to create collections inspired by great artists. Themes from the masterpieces of Gauguin, Miro, Degas, Chagall and many others adorned the collections each year, bringing its allure from the museum to the beach.

boldness and a dash of provocation drove Gottex to excel, launching flagship products that made their mark on the fashion market. When its "Hibiscus" collection was released in 1978, the brand launched its first pareo and triumphed around the world. But it was the famous "Seven Suit", created in 1984, that really put Gottex on the fashion-magazine covers. This swimsuit became the world's bestseller and earned the label enduring recognition. The strapless suit, often copied but never matched, highlights the shoulders and the feminine curves.

Competition is a constant challenge for Gottex. Besides its uncanny ability to adapt to social trends and its creative flair, the brand has displayed serious commercial savvy. In 1974, Gottex was the first brand to issue luxury catalogs with its new collections: these have even included gold-leaf etchings, and are much prized by image industry professionals. Gottex catalogs' are so stunning, that some

people avidly collect each one of them and keep them in their library, next to art books.

When looking at a Gottex catalog, it is always amazing to recognize women who are now supermodels in their early steps. Gottex had a visionary touch with its choice of models: from Paulina Porizkova to Tyra Banks, through Stephanie Seymour, Cindy Crawford, Laetitia Casta, Claudia Schiffer and Naomi Campbell. Indeed, being a Gottex model has helped launch several successful careers. Tami Ben Ami, Mrs. Gottlieb's muse and Gottex house model at age 18, quickly rose to become Israel's top model and the number 1 ambassador for Gottex worldwide. In 1983 the brand held a private show for Brooke Shields, who had barely emerged from adolescence and was still graced by the aura of her success in *The Blue Lagoon*, which had introduced her to filmgoers three years previously.

g ottex quickly realised the importance of building a visual identity for its label: besides creating a logo (the famous elongated and elegant gold monogram), Gottex staged shows based on the haute couture format which became the signature of the brand. In 1996, in a defining moment, Gottex organized a private fashion show in London for Lady Di and the elegant princess fell in love with the fabulous designs and ordered several styles to be made to her measurements. On 18 October 1996, Lady Di sent a handwritten letter to Lea Gottlieb: "Dearest Mrs. G., I so enjoyed our meeting here in London, and I wanted to thank you from the bottom of my heart for your kindness and generosity." The letter is simply signed

"Diana". This is not the only token of affection received by the brand, which in its archives stores many warmly enthusiastic messages from celebrities–Ivana Trump, Elizabeth Taylor and Nancy Kissinger, to name but a few.

In 2004, in a brilliant marketing move, Gottex presented a stunning one piece design made from precious gems, worth an estimated $30 million during New York Fashion Week. This masterpiece, the world's most expensive swimsuit, comprised one hundred perfect brilliant diamonds of 0.50 carats each, and a 130-carat Golconda diamond in the shape of a pear. The event was even screened live in Times Square.

t he Gottex name swiftly crossed borders and acquired an international dimension. By 1985 Gottex was selling more than one million items a year. Today, the brand is distributed in more than eighty countries, and is sold to the most prestigious and exclusive department stores and boutiques around the world. Following the sale of the shares held by the Gottlieb family (who are no longer involved in the company's operation), Gottex was acquired in 1997 by Mr. Lev Leviev, the owner of the Africa-Israel Group. Mr. Leviev, known for his remarkable vision and winning business strategies, made the acquisition of Gottex the cornerstone of the now leading Africa-Israel fashion division. In a move designed to enhance corporate management, Africa-Israel entered into partnership with the current president of Gottex, Mr. Joey Schwebel, to make certain that the label's steady success continues. This strong leadership has helped contribute to the remarkable growth of Gottex during the ensuing period. In the lobby of its headquarters in Or Yehuda, near the Tel Aviv airport, pareos designed by

Lea Gottlieb adorn the walls like trophies—embodiments of emotion and talent spanning fifty years. Some fifty designers and pattern-makers work on the collections, and put forward a thousand fabric swatches before finalizing the wonderful designs. Gottex continues to invest tremendous efforts and resources to ensure its reining status at the top.

f ive decades after it was founded, Gottex is continuing to enhance the shape and style of women who favour comfort, quality and glamour for their annual rendezvous with the sun. Nowadays, from Punta del Este to Porto Cervo, through the French Riviera or Mustique Island, the eyes of an expert might recognize a Gottex design. No matter her age or size, Gottex's swimsuits and beachwear always make a silhouette glamorous and outstanding by giving a woman a *je-ne-sais-quoi* which brings out her star qualities.

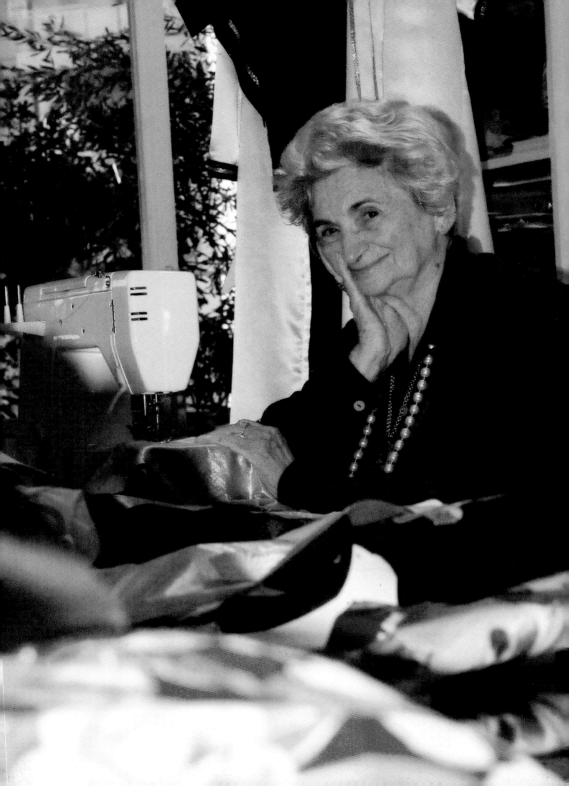

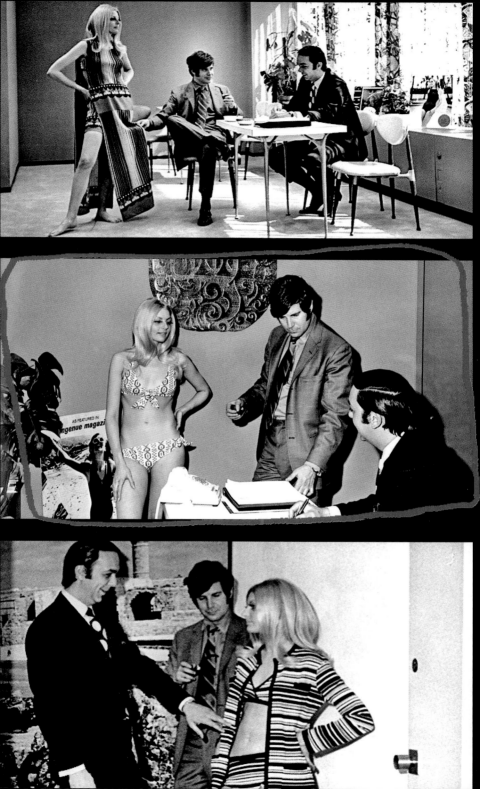

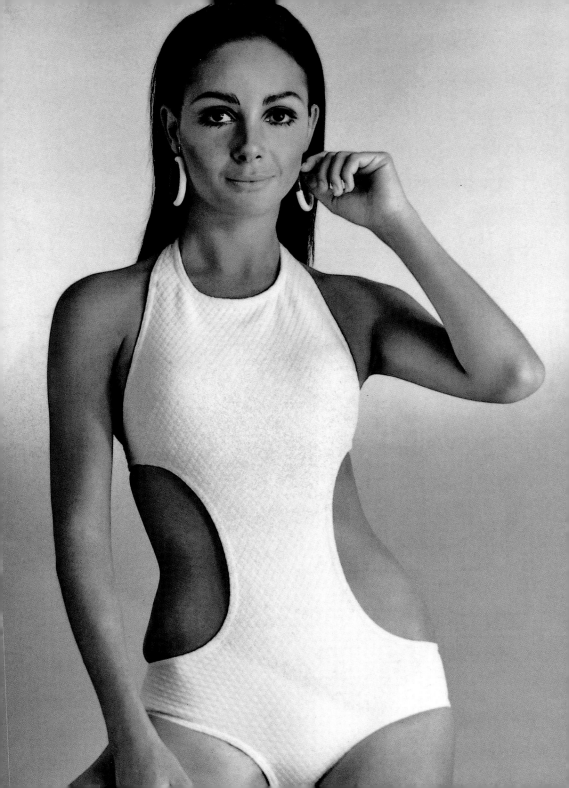

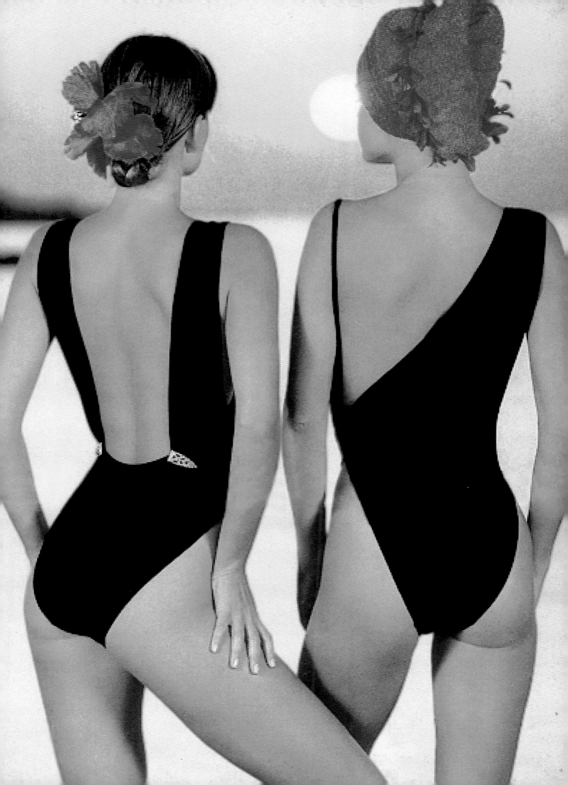

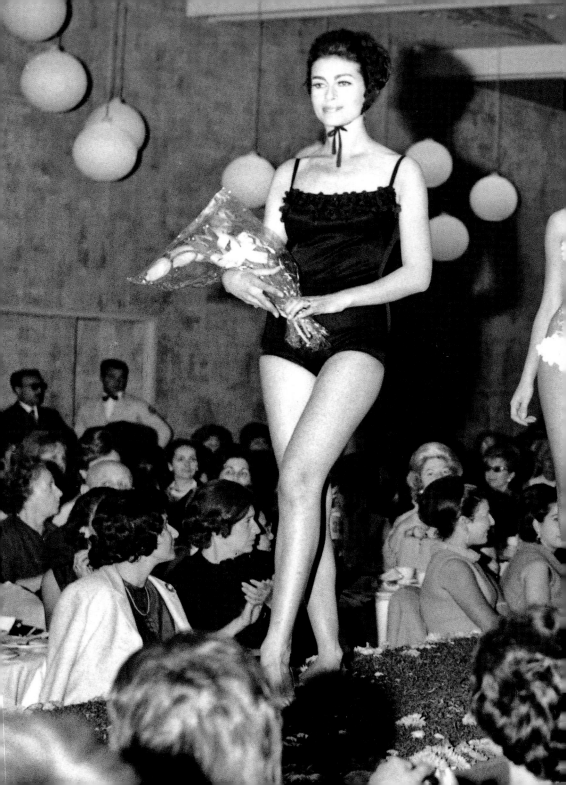

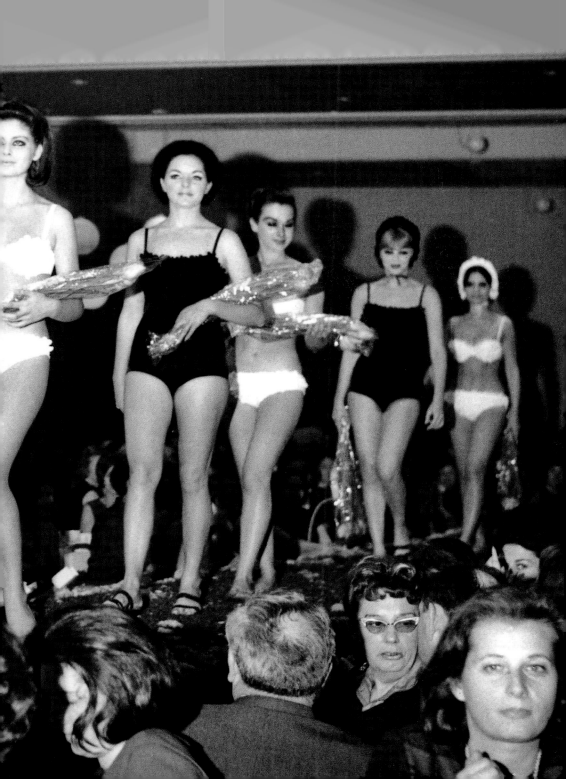

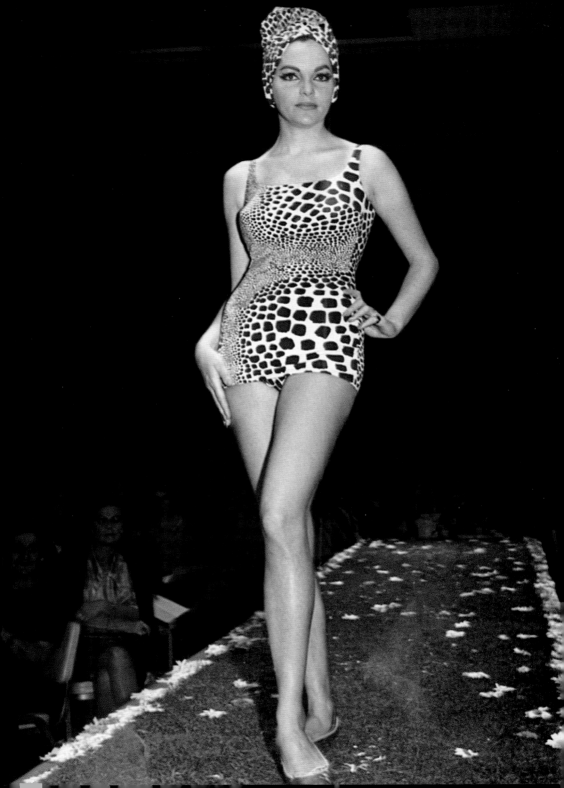

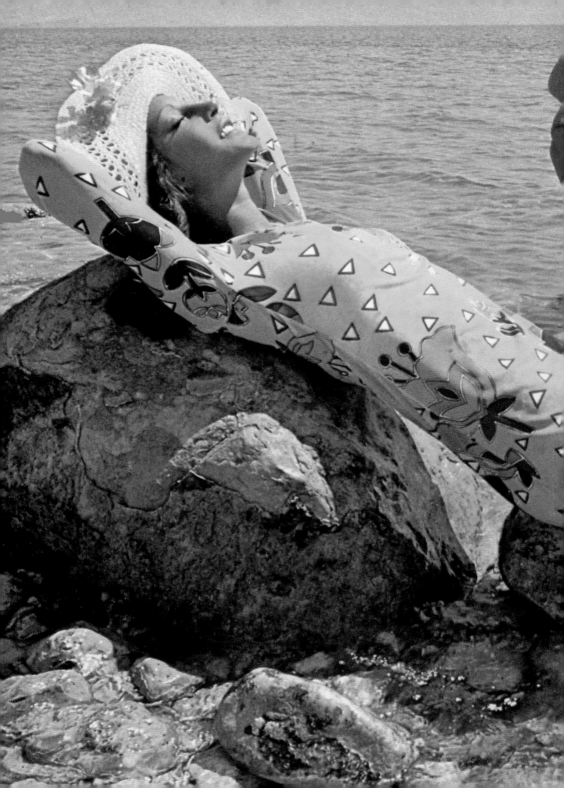

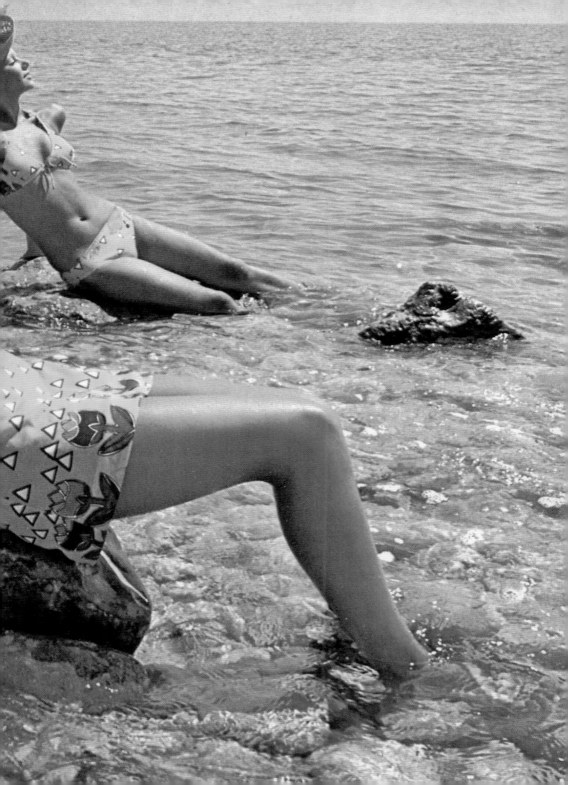

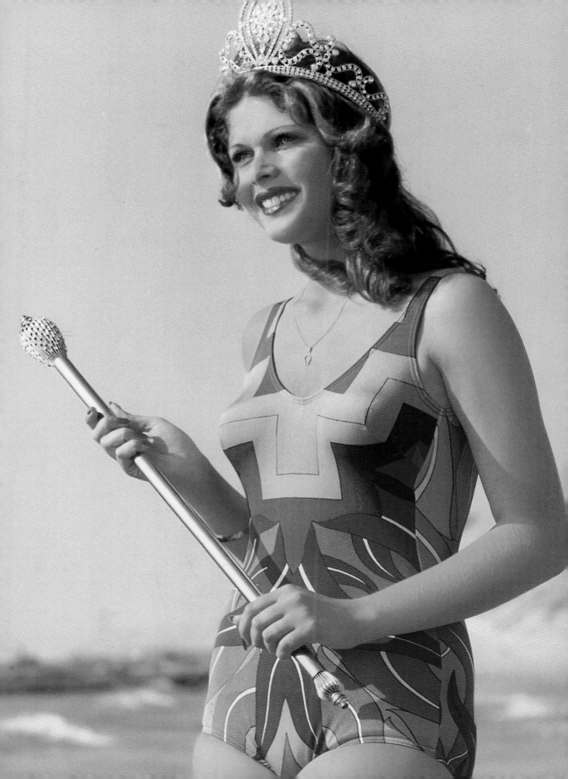

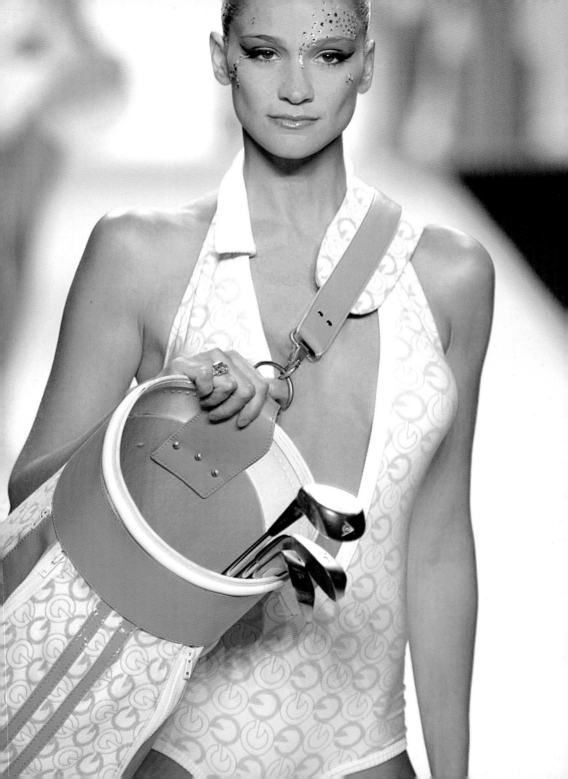

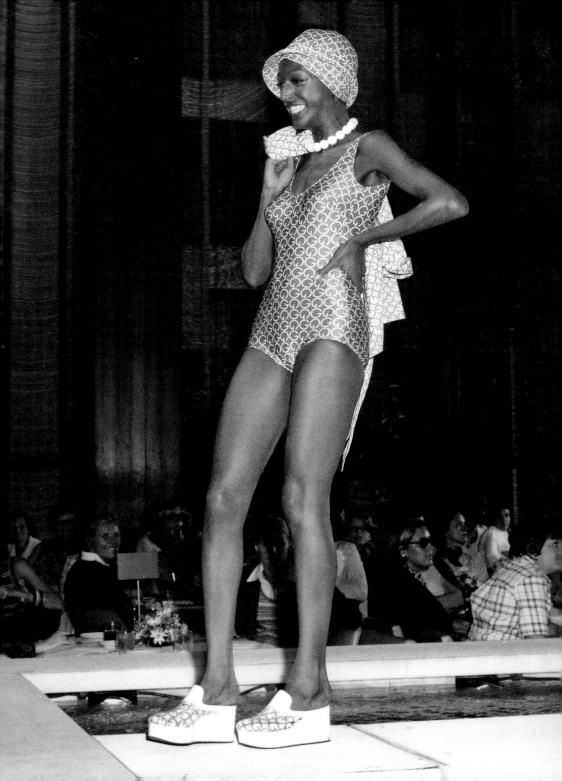

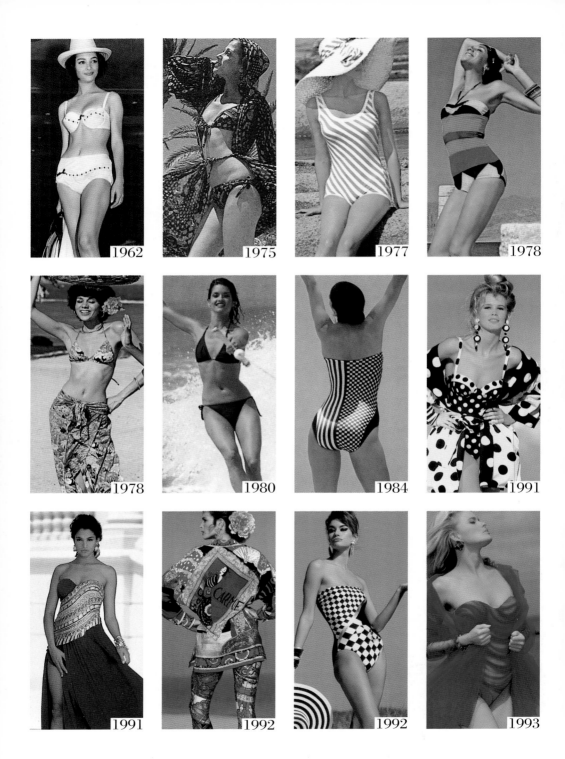

1962

1975

1977

1978

1978

1980

1984

1991

1991

1992

1992

1993

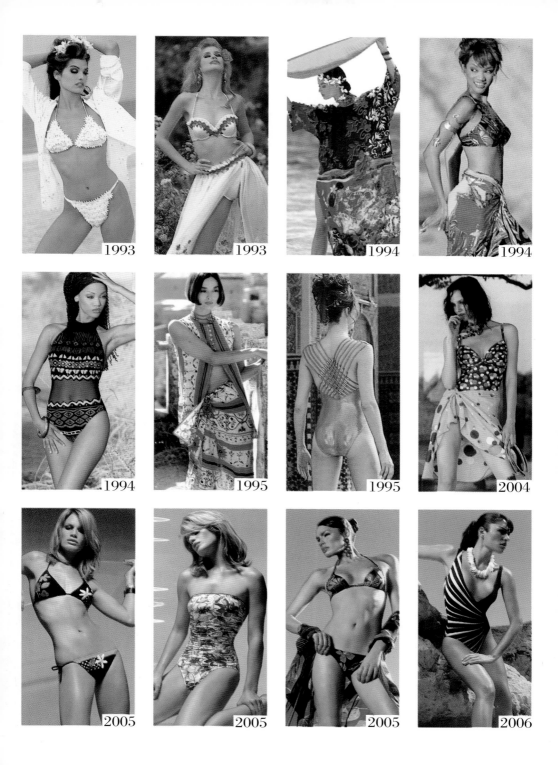

1993

1993

1994

1994

1994

1995

1995

2004

2005

2005

2005

2006

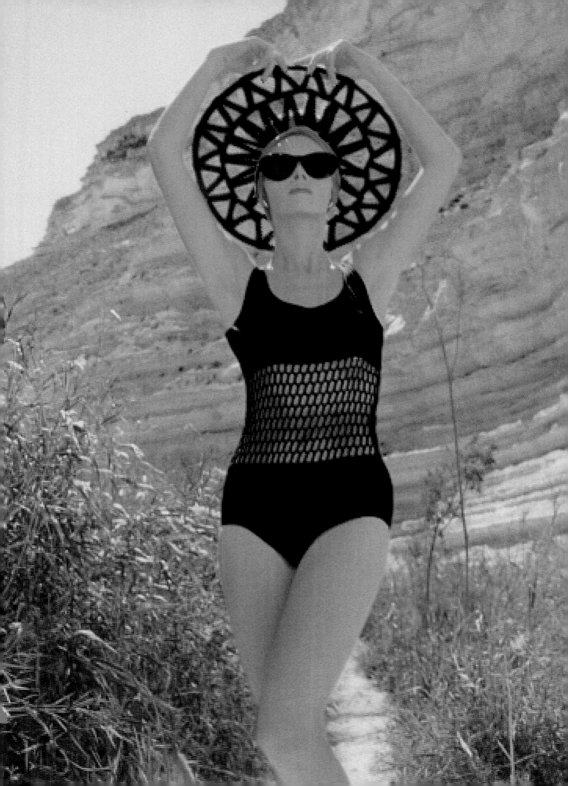

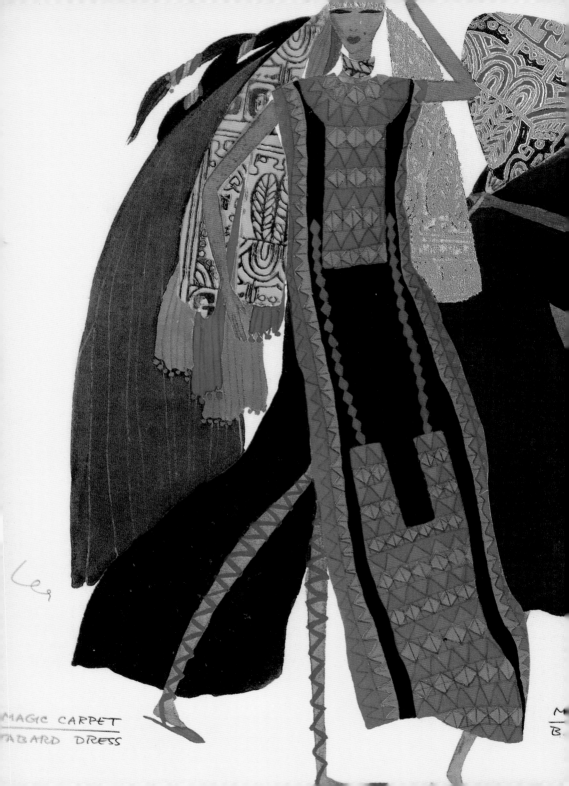

MAGIC CARPET
TABARD DRESS

M
B.

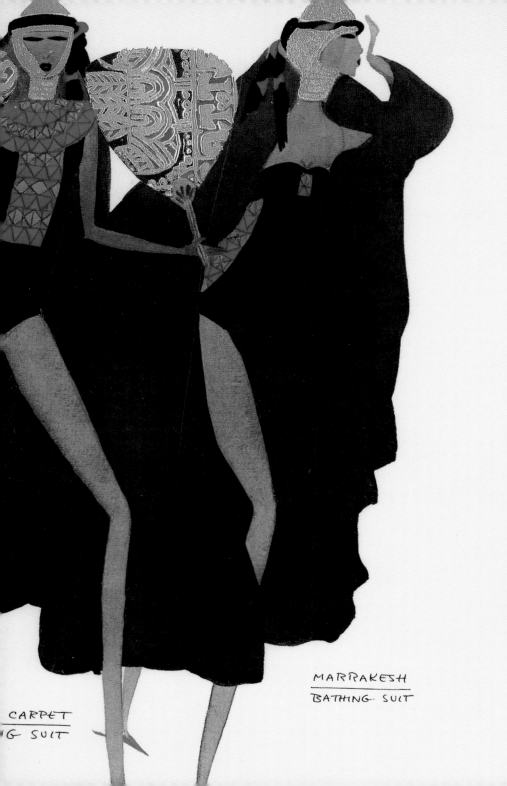

CARPET
G SUIT

MARRAKESH
BATHING SUIT

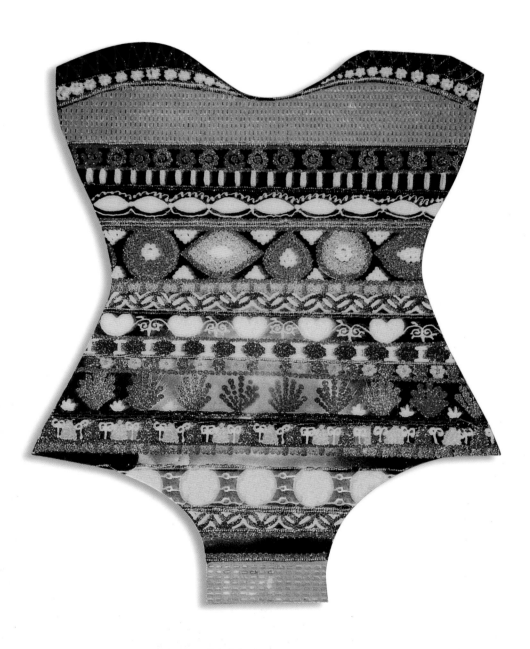

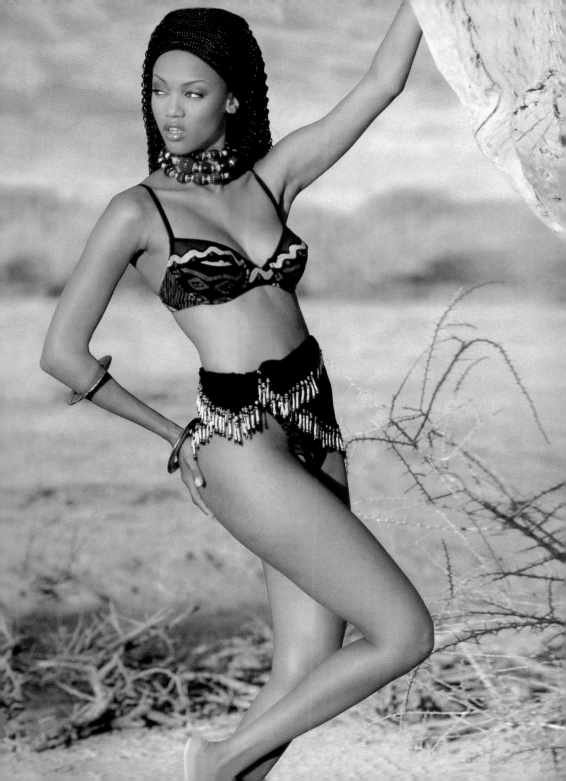

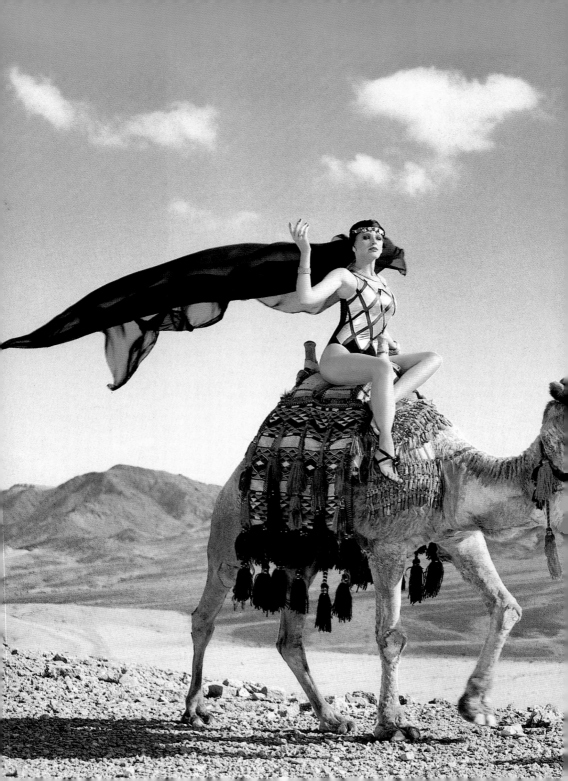

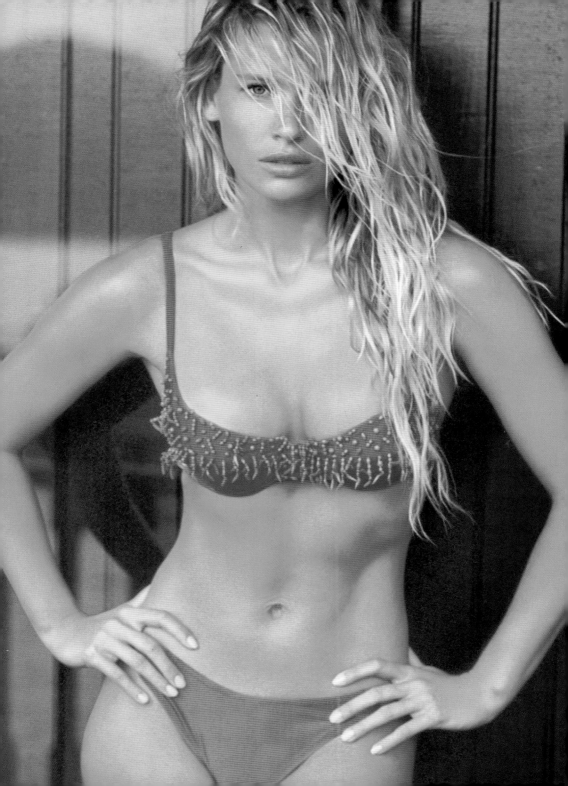

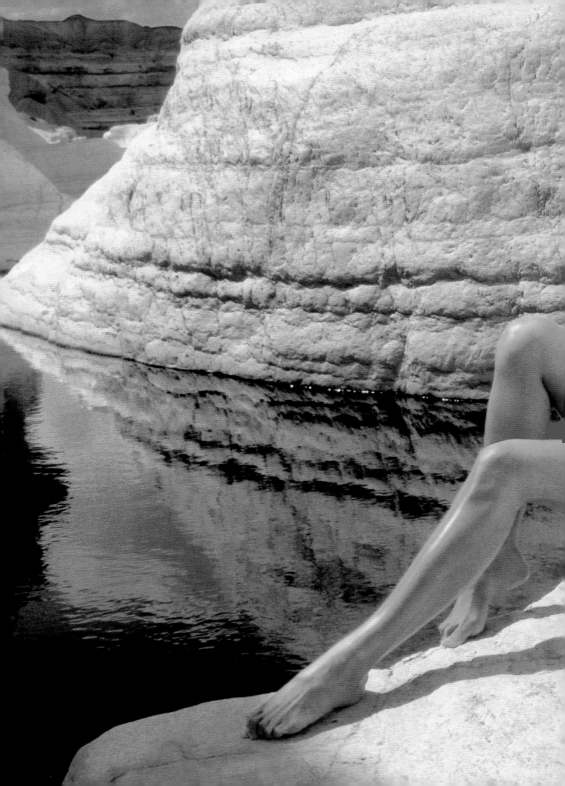

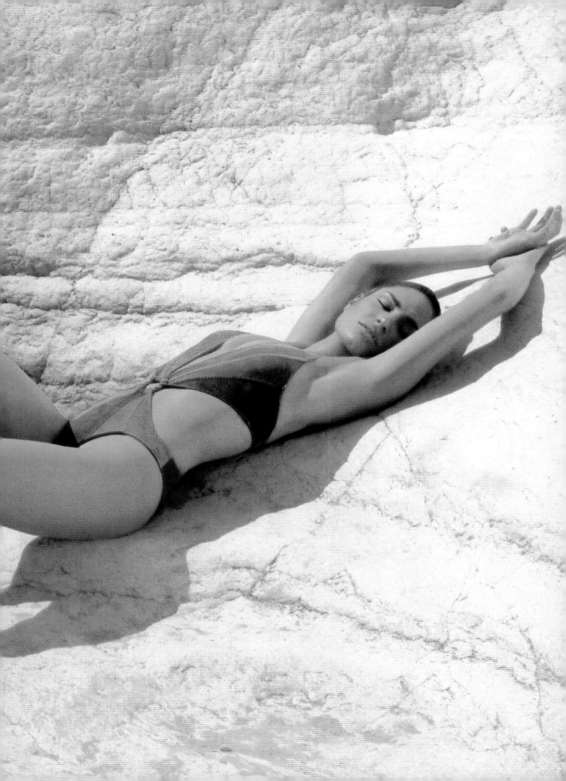

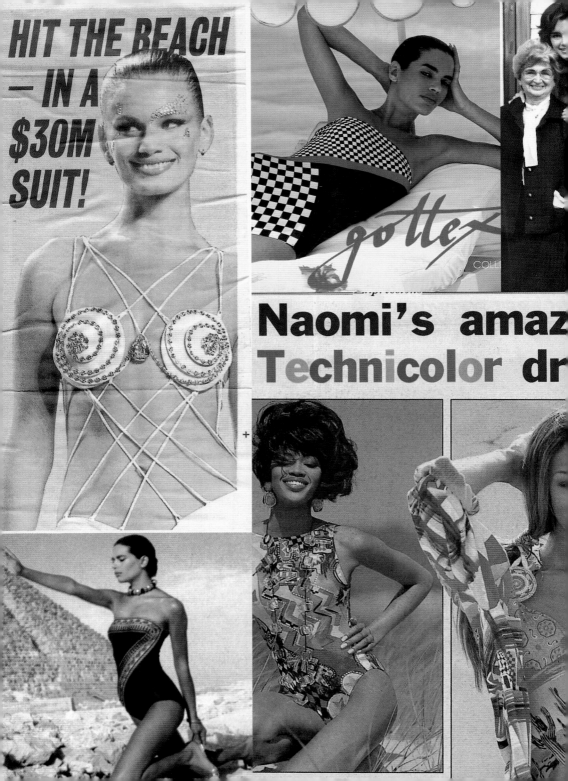

HIT THE BEACH — IN A $30M SUIT!

gottex

COLL

Naomi's amaz
Technicolor dr

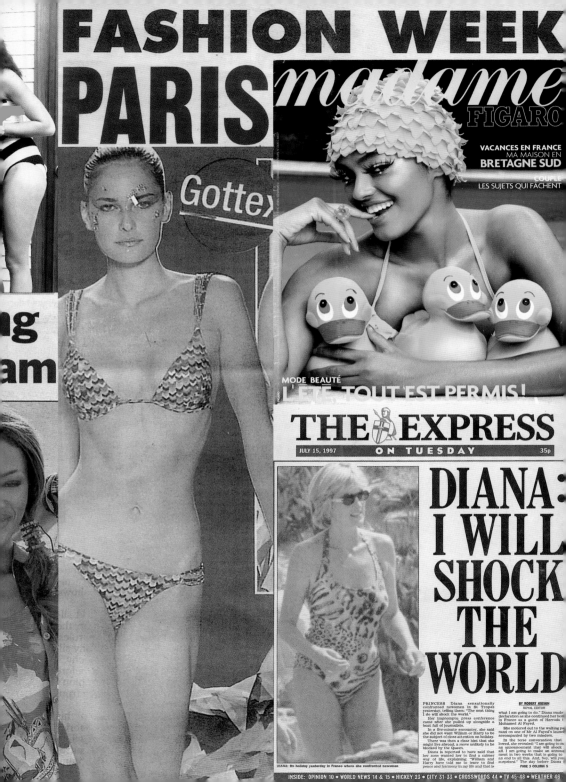

FASHION WEEK
PARIS

Gottex

madame FIGARO

VACANCES EN FRANCE
MA MAISON EN
BRETAGNE SUD

COUPLE
LES SUJETS QUI FÂCHENT

MODE BEAUTÉ
L'ÉTÉ, TOUT EST PERMIS!

THE EXPRESS
JULY 15, 1997 — ON TUESDAY — 35p

DIANA: I WILL SHOCK THE WORLD

BY ROBERT JOBSON
ROYAL EDITOR

PRINCESS Diana sensationally confronted newsmen in St Tropez yesterday, telling them: "The next thing I do will shock the world."

Her impromptu press conference came after she pulled up alongside a boat full of journalists.

In a five-minute encounter, she said she did not want William or Harry to be the subject of close attention on holiday.

There was then a clear hint that she might live abroad, a move unlikely to be blocked by the Queen.

Diana is reported to have said that her sons wanted her to find a calmer way of life, explaining: "William and Harry have told me to leave to find peace and harmony in my life and that is

what I am going to do." Diana made declaration as she continued her holiday in France as a guest of Harrods boss Mohamed Al Fayed.

She motored out to the waiting paparazzi on one of Mr Al Fayed's launches accompanied by two minders.

In the terse conversation that followed, she revealed: "I am going to make an announcement that will shock all. I am going to make an announcement in two weeks that is going to an end to all this. And, boy, will you surprised." The day before Diana

PAGE 5 COLUMN 5

DIANA: On holiday yesterday in France where she confronted newsmen

INSIDE: OPINION 10 • WORLD NEWS 14 & 15 • HICKEY 23 • CITY 31-33 • CROSSWORDS 44 • TV 45-48 • WEATHER 46

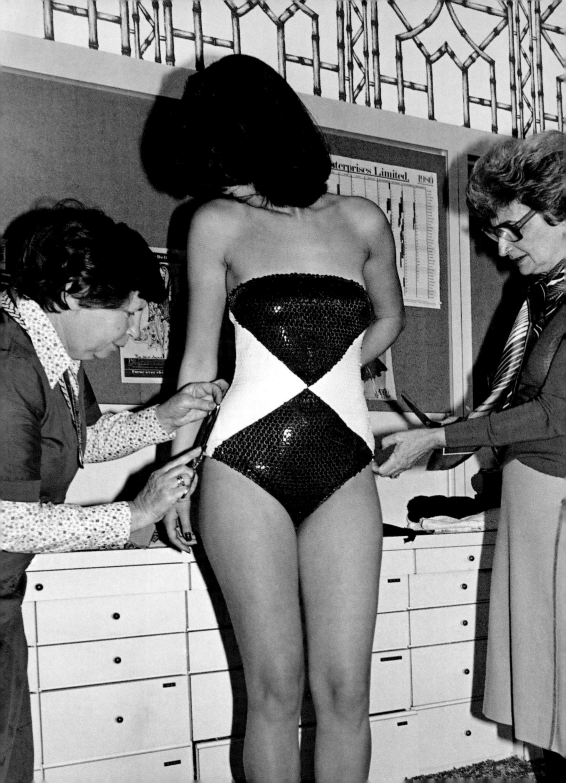

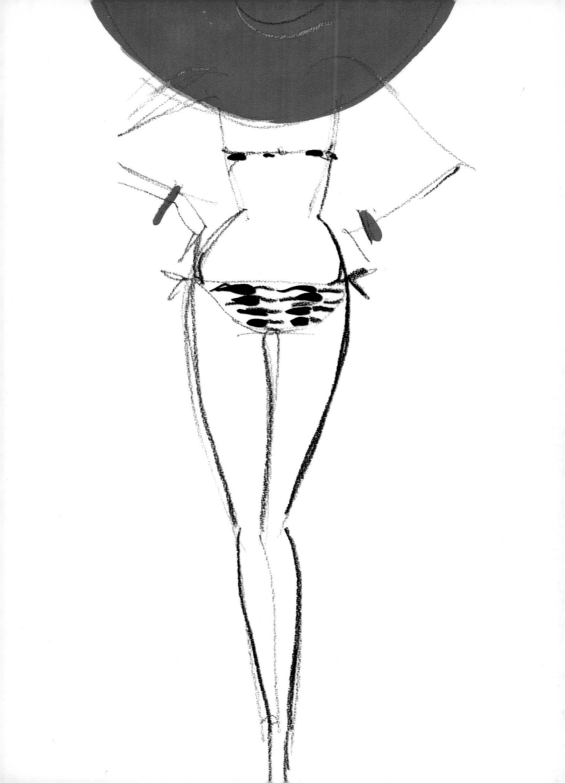

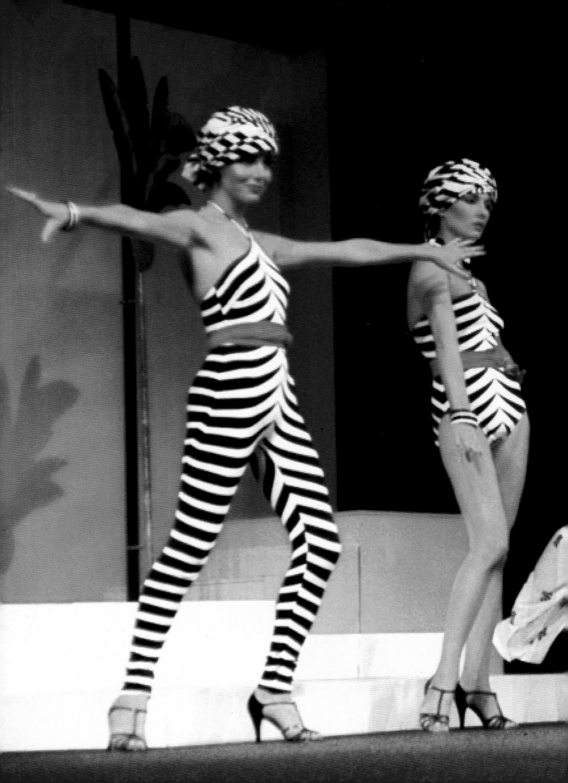

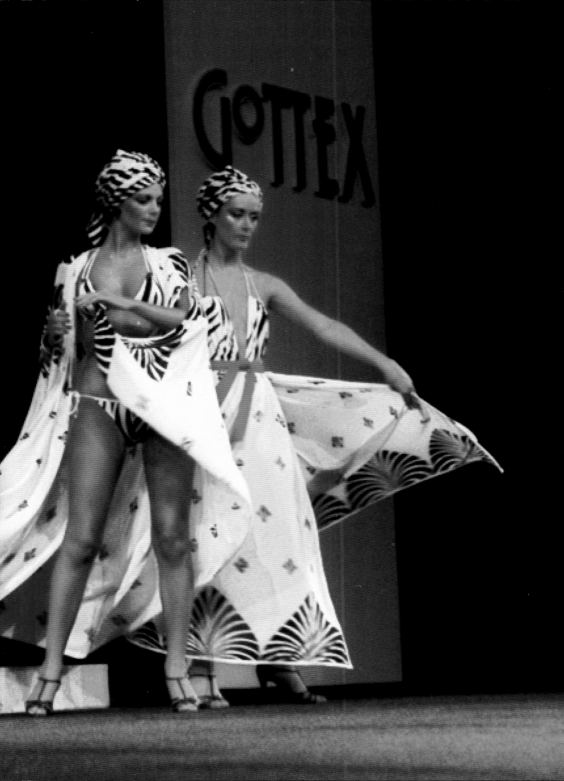

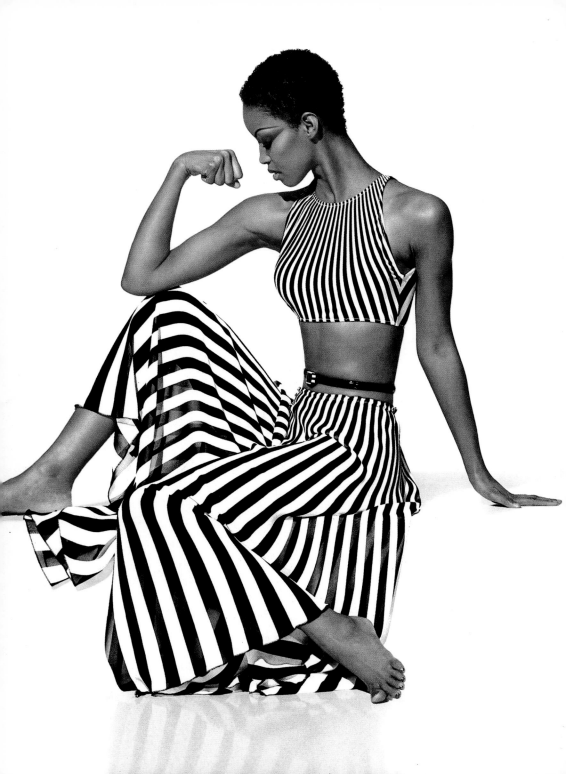

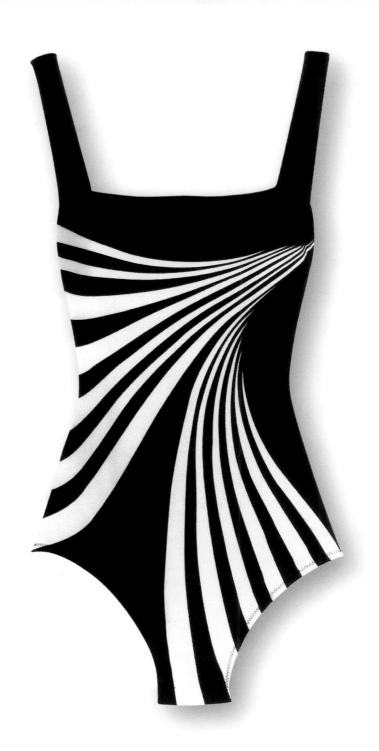

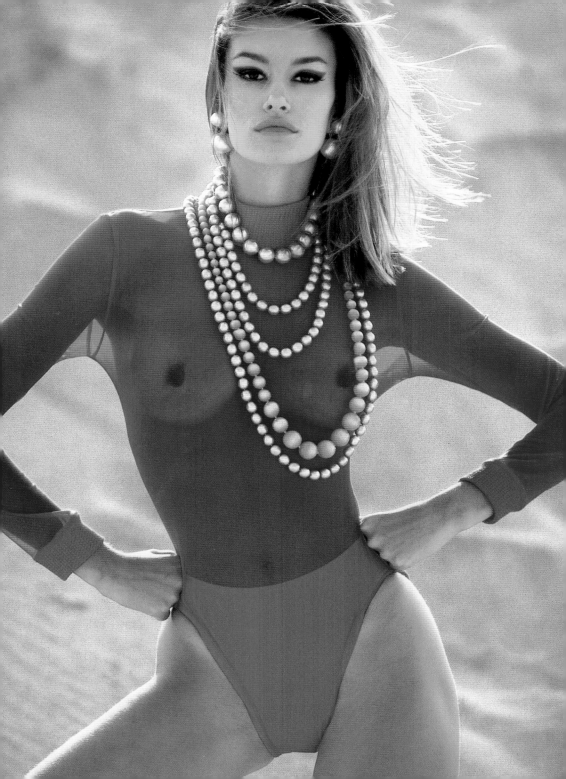

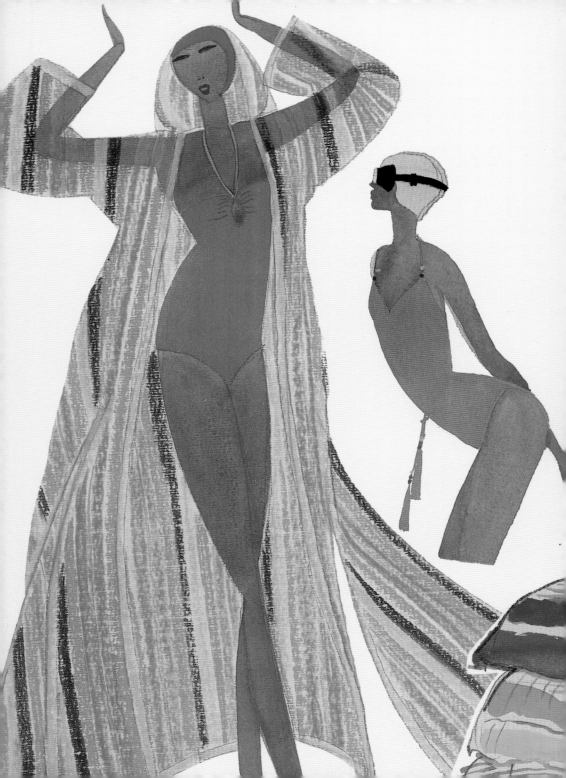

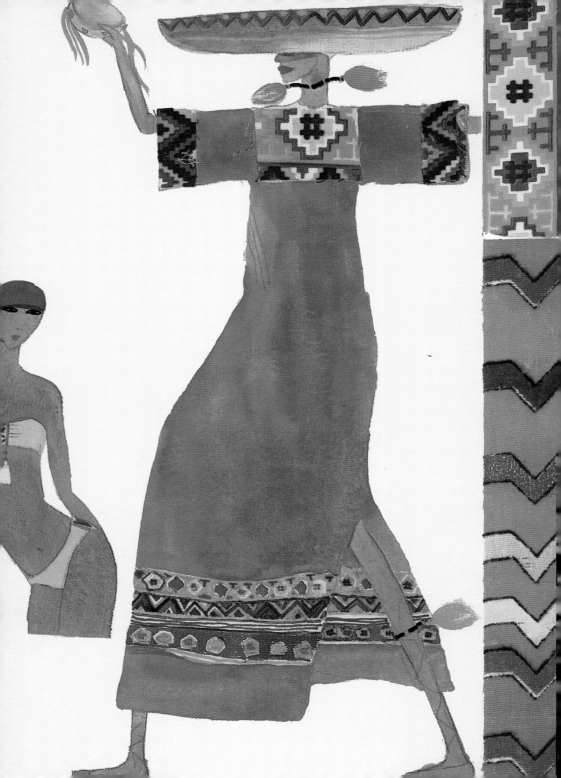

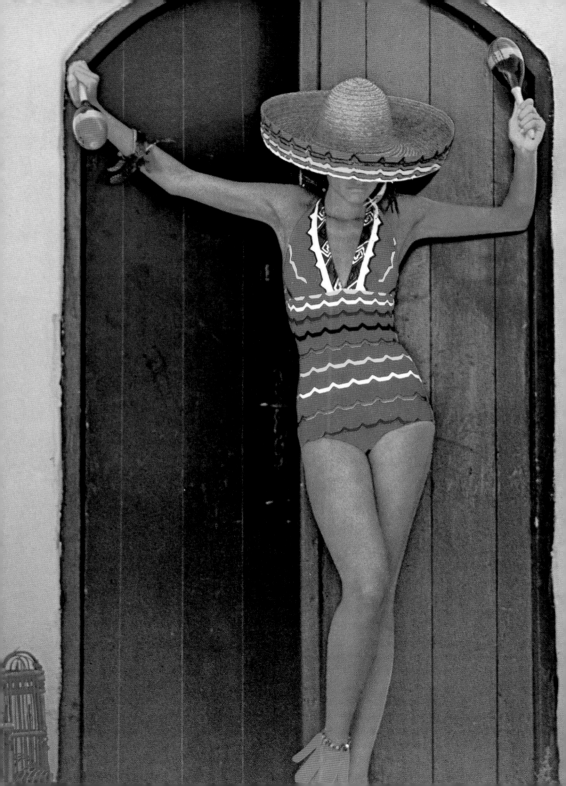

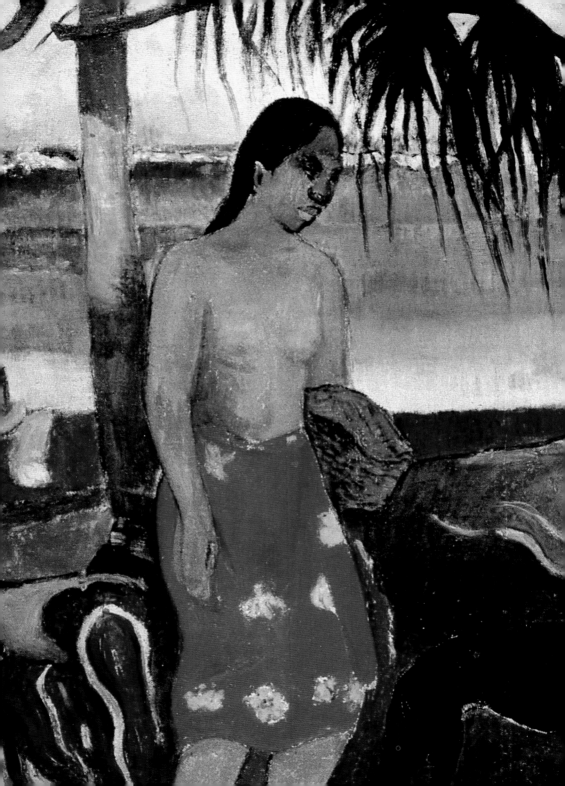

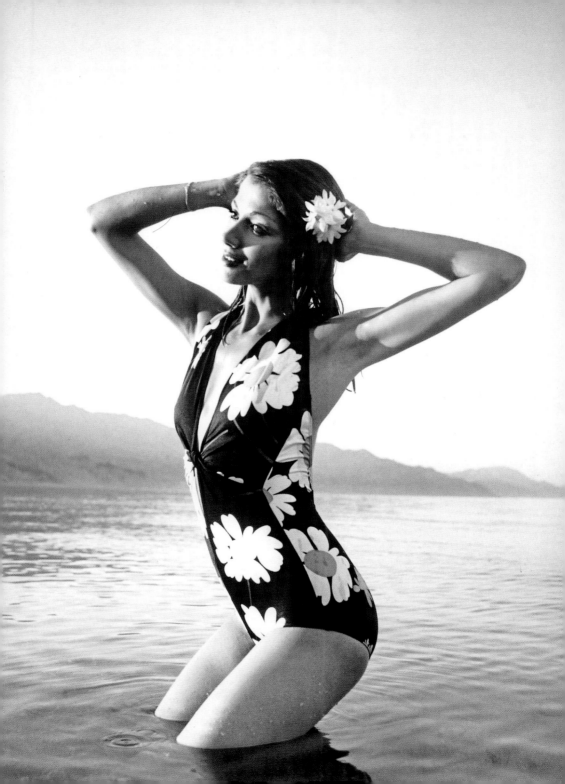

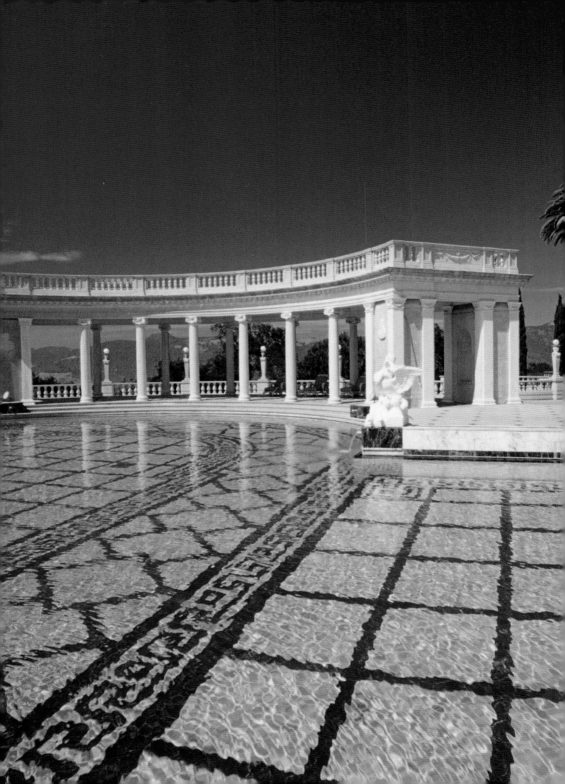

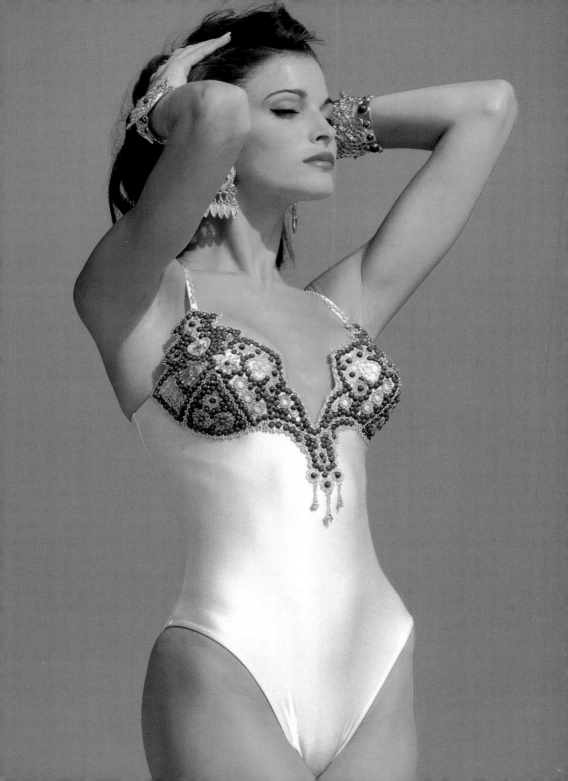

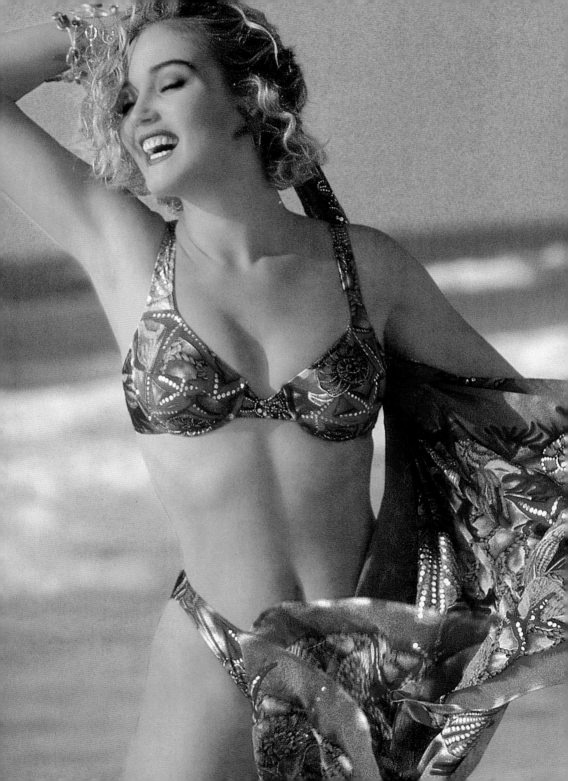

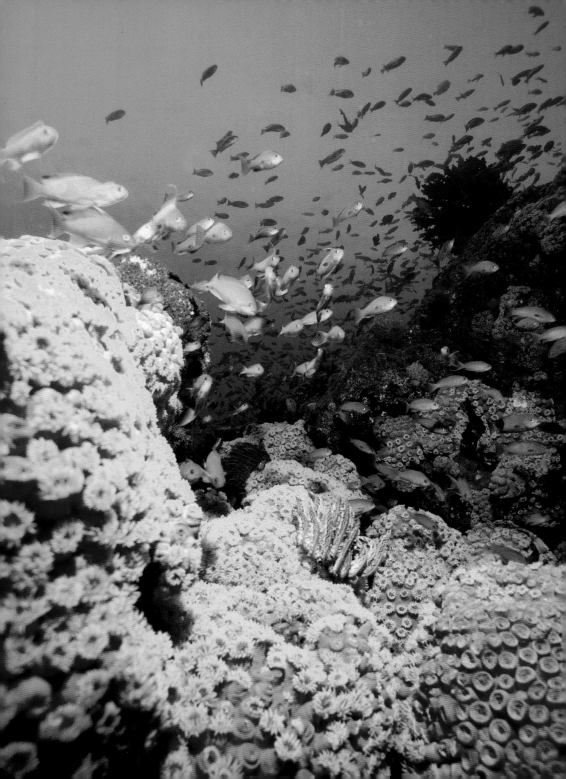

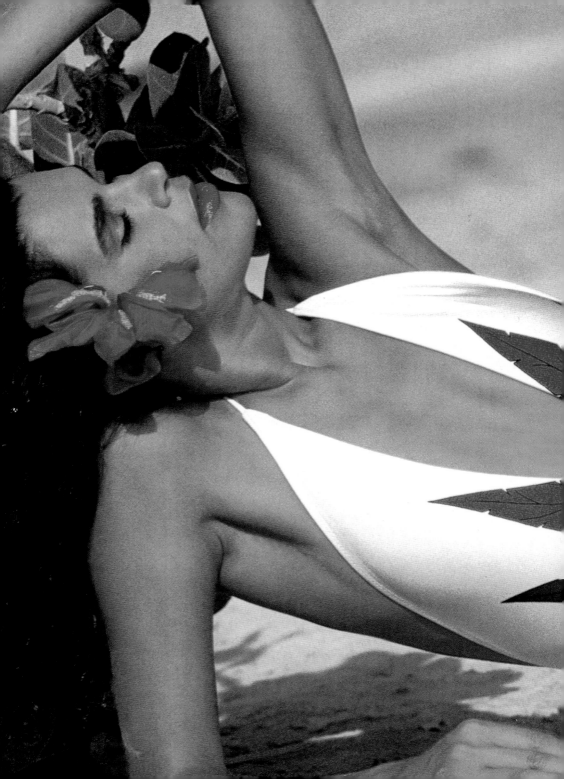

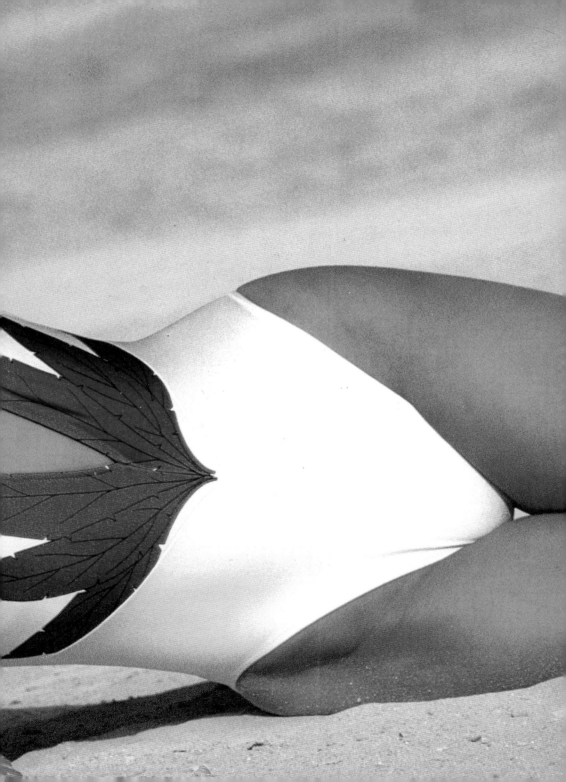

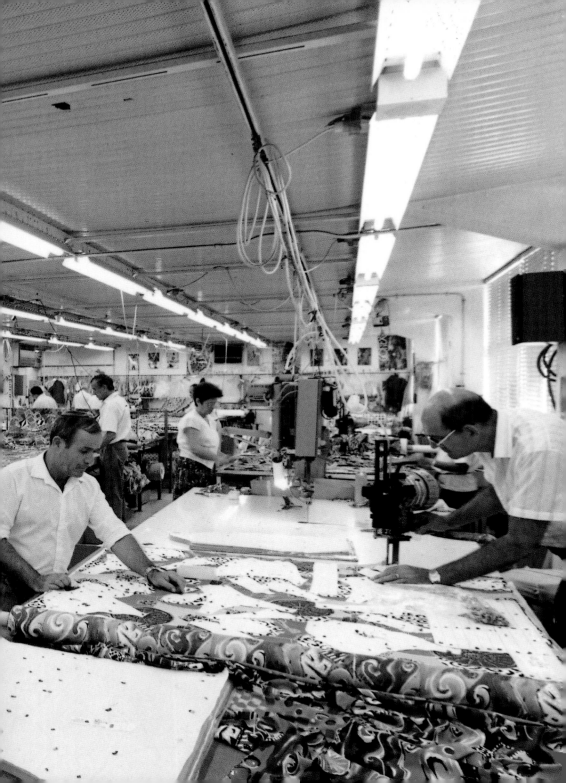

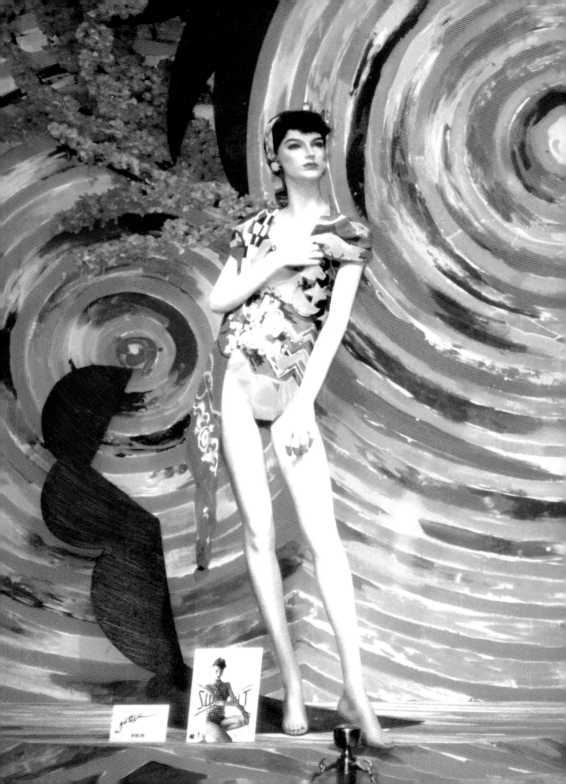

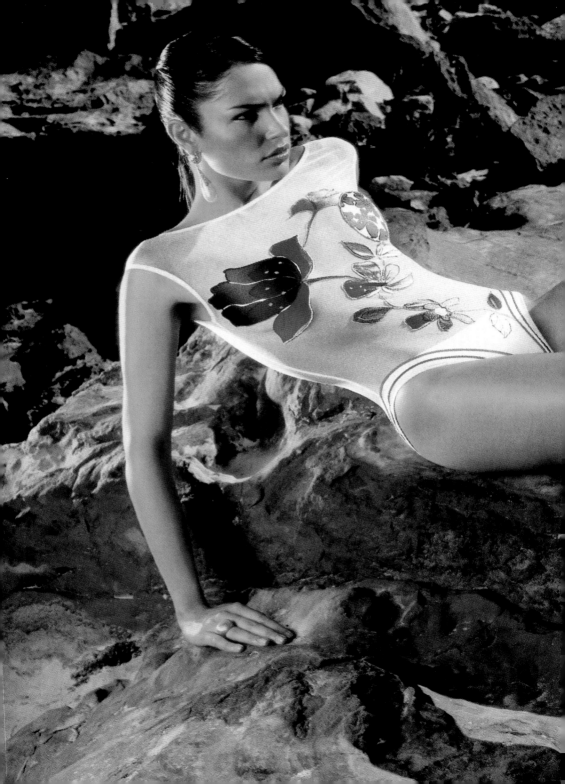

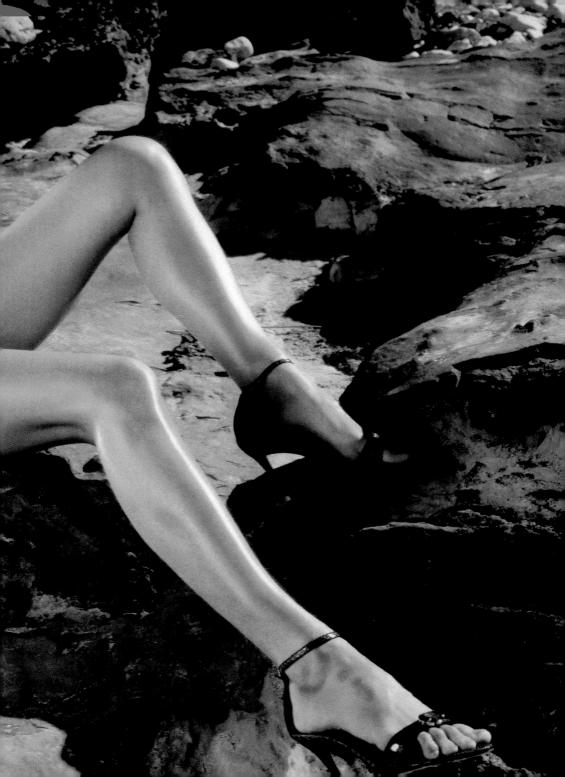

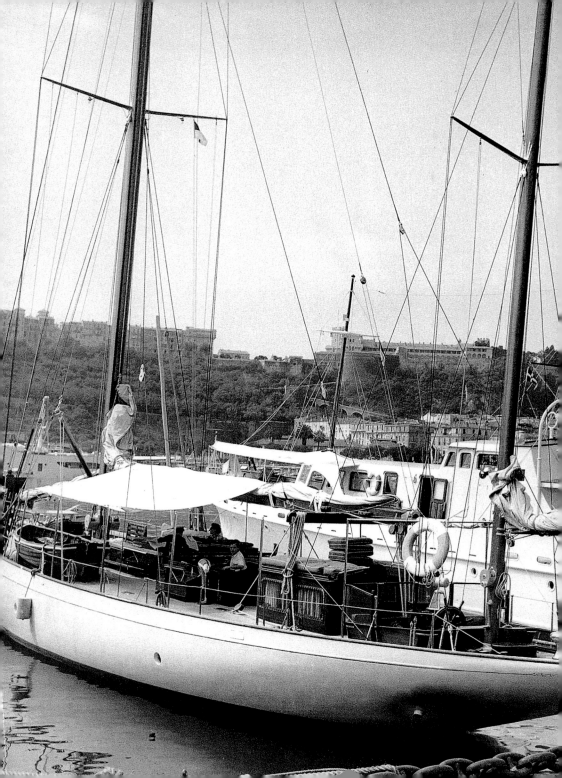

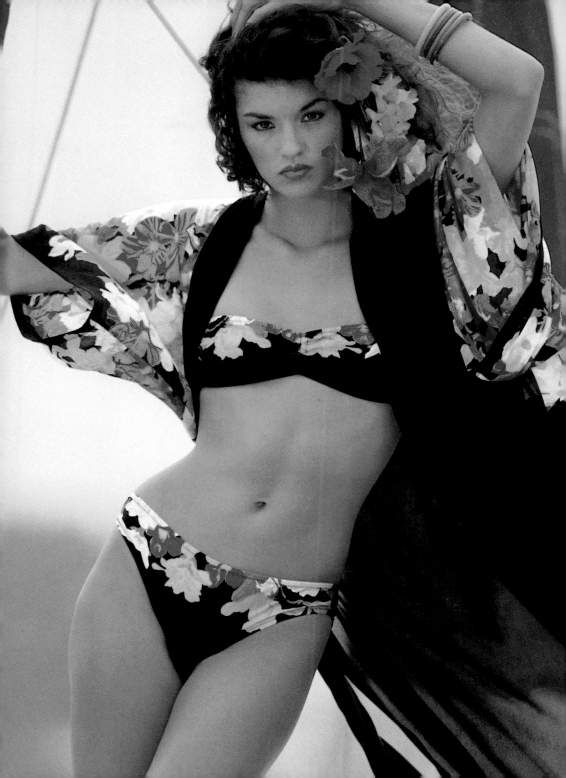

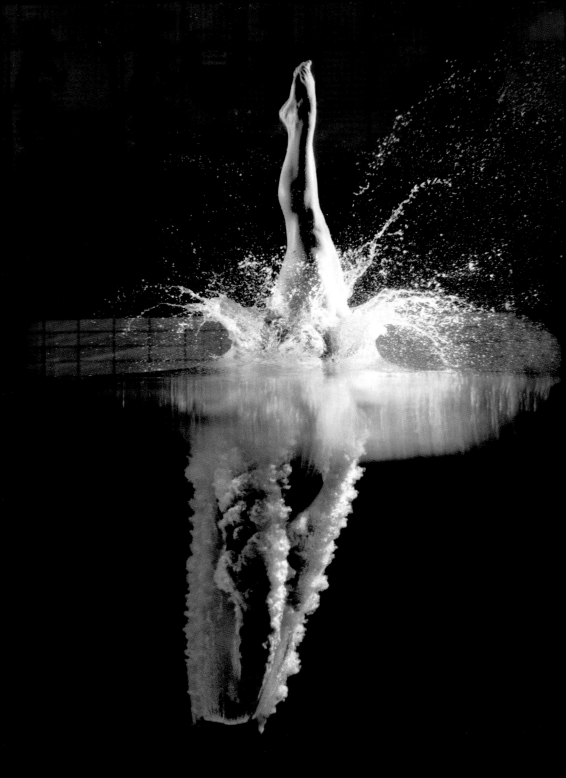

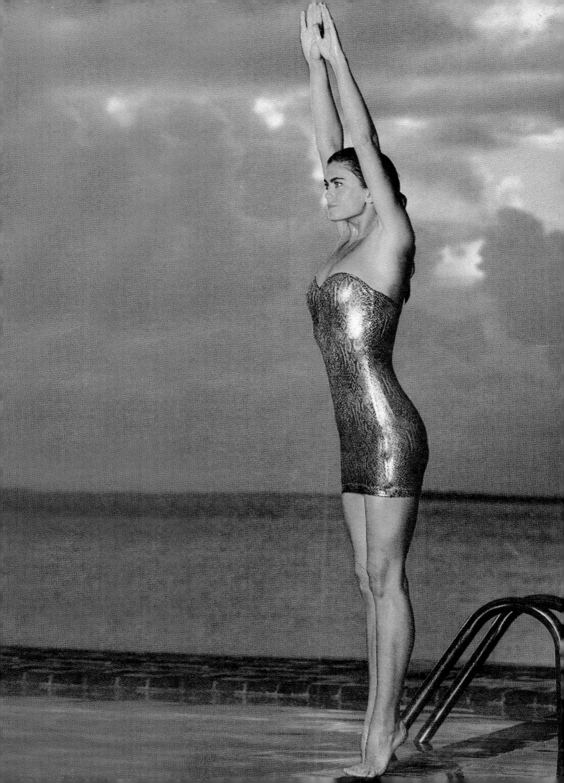

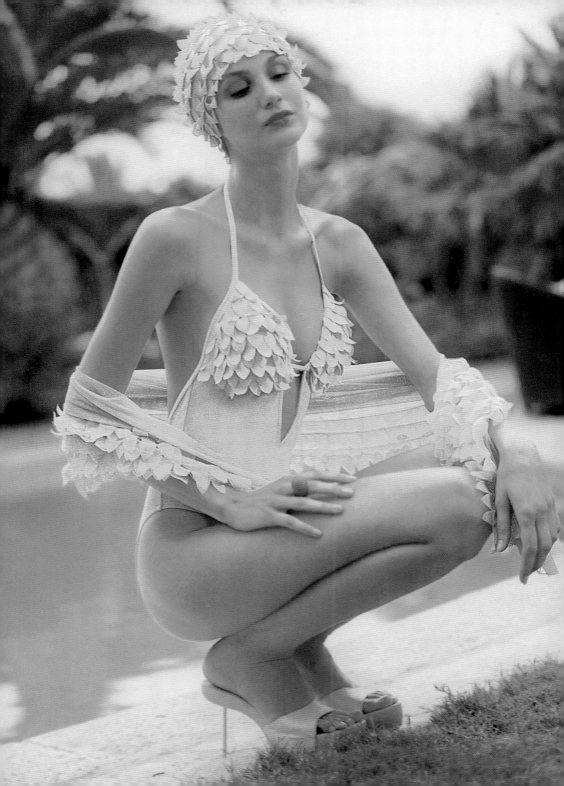

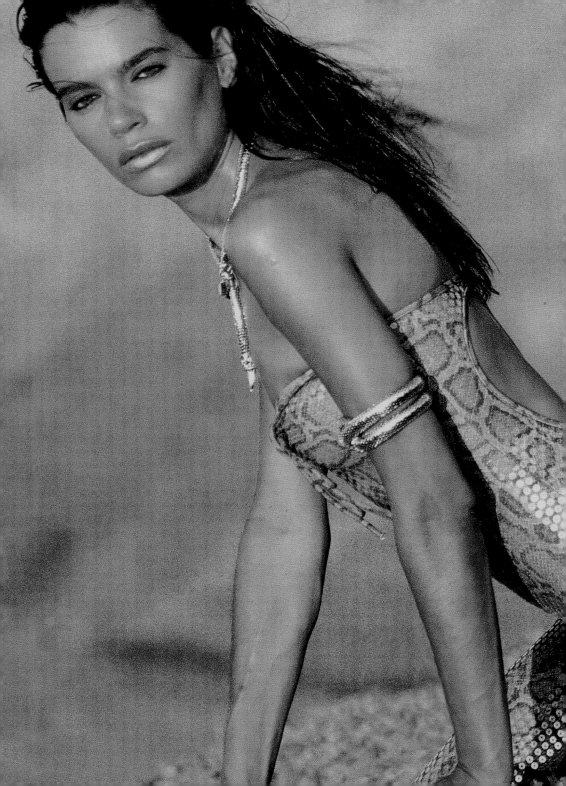

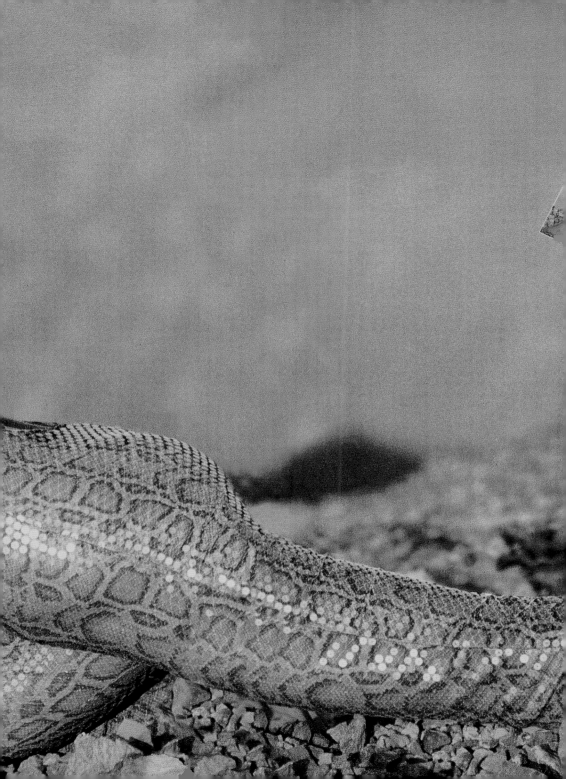

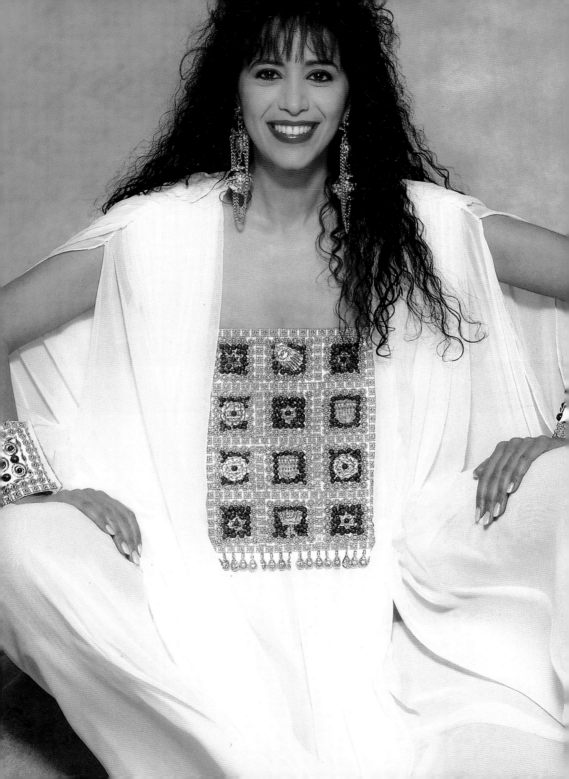

Chronology

1918: Birth of Leika Broth in Hungary.

1939: Lea's husband, Armin Gottlieb opens a raincoat factory in Budapest.

1940: Lea Gottlieb studies biochimy.

1944: Because of World War II, Armin is sent to a camp. With their two young daughters, Lea manages to escape.

1949: The Gottlieb family arrives in Israel with only 100 dollars in their pockets.

1952: Armin borrows a sewing machine and sells Lea's wedding ring in order to buy fabric.

1956: Lea starts to produce swimsuits under the name Gottex.

1958: Gottex launches the first swimsuit in printed lastex and is the first brand in the world to adopt Lycra blend fabrics.

1962: First fashion show in Tel-Aviv, Sheraton Hotel.

1963: First fashion show in London.

1965: Gottex makes the front cover of the international press.

1972: Gottex receives the first prize in the international fashion festival in Cannes (France).

1973: First fashion show in New York, Four Seasons Hotel.

1974: Publication of the first Gottex catalog, which would mark the beginning of a unique creative cooperation with Turnowsky, a leading publisher of fine paper products.

1976: Opening of a corner at Harrods (London). Gottex participates in the first international swims exhibition (Paris); IGEDO (Dusseldorf International fashion fair); Copenhagen International Fashion Fair (CIFF).

1978: "Hibiscus" collection. Launching of the first pareo.

1979: Gottex receives Israel's prize in recognition of its exceptional achievement in enhancing Israel's industrial image and worldwide reputation.

1981: Lea Gottlieb receives the award for outstanding designer of the year at IGEDO (Dusseldorf).

1983: The young actress Brooke Shields visits Israel and Gottex holds a private fashion show for her.

1984: Gottex launches the Seven suit which has become the world's best selling swimsuit.

Ofra Haza, Israeli singer, wearing a "Jerusalem of gold caftan", 1992. © Ben Lam/Turnowsky/Gottex.

1985: Gottex's success story is published in *Time* magazine and is read by millions of people.

1986: Supermodel Paulina Porizkova is the cover girl for 1986's catalog, paving the way for many more supermodels in the years to come.

1991: Claudia Schiffer appears for the first time on the cover of the catalog, in a stunning white cotton blouse inspired by the Czardas Hungarian folk dance.

1992: The world-renowned photographer Patrick Demarchelier is chosen to shoot the catalog. The shooting takes place in the Hamptons with Naomi Campbell, Stephanie Seymour and Susan Holms.

1993: Claudia Schiffer, Mrs Gottlieb's favorite model, appears in a catalog which is a tribute to the Opera and the Bolshoy Ballet: "La vie en rose".

1994: "Africa" collection. Tyra Banks makes an unforgettable appearance in a catalog that celebrates nature.

1997: Lady Di, one of Gottex's most respected and adored customers, is wearing a Gottex animal print swimsuit while on vacation. Pictures of her adorn newspapers around the world. Africa Israel buys Gottex.

1998: Gottex's glamourous black and orange "Poppies" collection is a world wide success.

2003: Gottex is the only swimwear brand to participate to the prestigious New York Fashion Week.

2004: During New York Fashion Week, Gottex presents a swimsuit with a 103 karat diamond, worth over $ 30,000,000 . The event is broadcasted live in Times Square on huge screens.

2005: Presentation during New York Fashion week of a 18 karat gold bikini, made of thousands of tiny gold bamboo leaves.

2006: Gottex celebrates it's 50th anniversary.

Tami Ben Ami in a "Berlioz" Bikini and caftan, 1982. © Ben Lam/Turnowsky/Gottex.

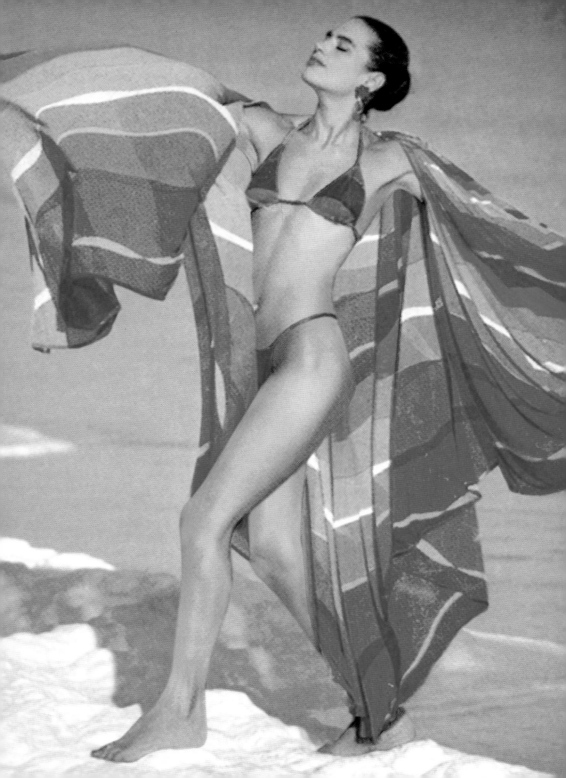

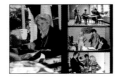

Mrs Lea Gottlieb, founder of Gottex, in 2001. © Gottex.
Buyers at a swimwear exhibition in 1972. © Gottex.

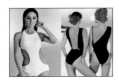

White swimsuit, 1965. © Gottex.
"Bijou" and "Belle" swimsuits from 1986 catalog. © P. Curto/Turnowsky/Gottex.

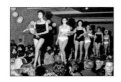

Fashion show in Tel Aviv, 1962. © Gottex.

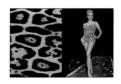

Years before other brands have dared to use it, Gottex has introduced leopard in its collections. © Laziz Hamani.
Fashion show in Tel Aviv, 1962. © Gottex.

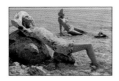

"Petale" dress and Bikini worn by Chani Perri, 1974. © Ben Lam/Turnowsky/Gottex.

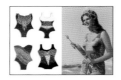

Swimsuit models designed by Vernet. Clockwise: JOSS 1411; ET 147; FA 1067; S 5711. © Gottex.
The Israeli Rina Mor, Miss Universe 1976. © Gottex.

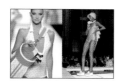

Come-back of the "G" monogram invented in 1973, as shown during New York Fashion week, 2005. © Gottex.
The original "G" monogram in a fashion show held at The Four Seasons hotel, New York, in 1973. © Gottex.

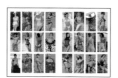

A selection of Gottex best-sellers swimsuits, from the 1960s to nowadays.
From left to right (top to bottom): photos 1 and 10: © Gottex; photos 2, 3, 4, 7, 8, 9, 11, 13, 14, 15: © Ben Lam/Turnowsky/Gottex; photos 5, 12 and 17: © Turnowsky/Gottex; photo 16: © Aldo Fallai/Optimum/Gottex; photos 19 and 20: © Patrick Demarchelier/Turnowsky/Gottex; photos 21 and 22: © Ron Kedmi/Optimum/Gottex; photos 23 and 24: © Eshel Ezer/Yehoshua TBWA/Gottex.

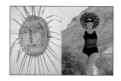

Sun in Joan Miro's studio in Palma de Majorque. © Jean-Marie Del Moral.
Collection "Sun and Stars", 1977. © Ben Lam/Gottex.

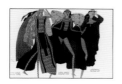

From left to right: **Magic carpet, Tabard dress; Magic carpet, bathing suit; "Marrakesh" bathing suit**, 1977. Drawn by Lea from Turnowsky. © Gottex.

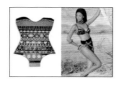

T1726 swimsuit, designed by Vernet. © Gottex.
Tyra Banks wearing a "Tom-Tom" Bikini and pareo, 1994. © Ben Lam/Turnowsky/Gottex.

Paula Abbott wearing a "Sahara" Swimsuit, *Town and Country* magazine, 1980.© Norman Parkinson.

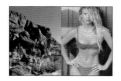

Ramon Crater, 2006. © Eshel Ezer/ Yehoshua TBWA/Gottex.
Daniela Pestova in a "Malaysia" Bikini, 2000. © Robert Erdman/*Sports Illustrated*.

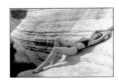

Jessica Aurora in a "Jungle Mist" swimsuit, 2006. © Eshel Ezer/Yehoshua TBWA/Gottex.

Clockwise: diamond swimsuit worth $30 millions. © Gottex; "Checkmate" swimsuit worn by Tami Ben-Ami, 1984. © Ben Lam/Turnowsky/Gottex; Mrs Lea Gottlieb and Brooke Shields, 1983. © Gottex; 1991 issue of *The Daily Express* © C. Allegri/Guetty Images; "Mermaid" swimsuit and bonnet, 2005. © John Huba; Lady Di wearing a leopard swimsuit, *The Express magazine*, 1997. © D.R.; Naomi Campbell wearing a "Josephine Baker" swimsuit in *The Daily Express*, 1991. © P. Demarchelier; The first Seven Suit "Nile", worn by Tami Ben-Ami,1984. © Gottex.

Mrs Lea Gottlieb fitting a "diamond" swimsuit, in her Yad Eliyahu studio in Tel Aviv, 1982. © Booz Lamir/Gottex.
"Zebra" Bikini drawn by Lea from Turnowsky. © Gottex.

"Zebra" collection, New York fashion show, 1980.© Gottex.

Georgianna Robertson wearing an "Optical Illusion" outfit, 1995. © Gilles Bensimon.
Black and white "Turning Point" swimsuit, 2005. © Gottex.

"Salinan" Bikini, 1992. © Patrick Demarchelier/ Turnowky/Gottex.
"Jericho" caftan and Bikini, drawn by Lea from Turnowky, 1977. © Gottex.

"Niroz" cotton dress with ethnic print, drawn by Lea from Turnowky, 1977. © Gottex.
"Acapulco" swimsuit, 1977. © Ben Lam/Turnowsky/Gottex.

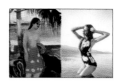

I raro te oviri (detail) by Paul Gauguin, 1891, 0,68 x 0,91 cm, Dallas Museum of Art.
© AKG-Images.
"Daisy" Swimsuit, from 1974, worn by Nechama Lev. © Ben Lam/Turnowsky/Gottex.

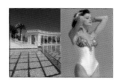

Neptune pool at Hearst Castle, 2000. © Joseph Sohm; ChromoSohm Inc./Corbis.
Stephanie Seymour in a "Jerusalem of gold" swimsuit, 1993. © Ben Lam/Turnowsky/Gottex.

"Sea Treasure" swimsuit, from 1994 collection, worn by Saphir Kaufman.
© Ben Lam/Turnowsky/Gottex.
School of Athias near Orange Cup Coral. © Corbis.

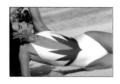

Tami Ben-Ami wearing a "Honolulu" swimsuit, 1982.
© Ben Lam/Turnowsky/Gottex.

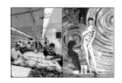

Gottex factory in Or Yehouda, Israel, 2001. © Gottex.
Mitzukoshi window in Tokyo, Japan, "Universe" collection, 1992. © Gottex.

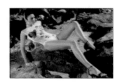

Jessica Aurora in a "Botanica" swimsuit, 2006 collection.
© Eshel Ezer/Yehoshua TBWA/Gottex.

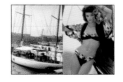

Yatchts in Monte Carlo port, 1958. © SBM/Gottex.
Janice Dickinson in a "Berenice" Bikini, 1980. © Mike Reinhardt/Turnowsky/Gottex.

Athlete Kathy Flicker, Princeton University, 1962. © George Silk/Time Life Picture/Getty Images.
Silver "Python" swimsuit, 1997. © Gottex.

O'Cotillo Lodge swimming pool, designed by Dan Palmer and William Krisel, 1956.© Aline Coquelle.
Yellow "Mermaid" swimsuit, pareo and cap, 2004.
© Aldo Fallai/Optimum/Gottex.

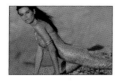

"Python" catsuit worn by Tami Ben-Ami, 1977. © Ben Lam/Turnowsky/Gottex.

The publisher would like to thank Mrs Lea Gottlieb, Joey Schwebel, Lev Leviev, Michal Ron Gavish.
Thanks are also due to: the late Lady Diana; Brooke Shields;.all the top models in this book: Paula Abbott, Vicky Andren, Jessica Aurora, Tyra Banks, Naomi Campbell, Janice Dickinson, Saphir Kaufman, Nechama Lev, Rina Mor, Ana Paula, Chani Peri, Georgianna Robertson,Daniela Pestova, Claudia Schiffer, Stephanie Seymour, and the late Tami Ben-Ami; the photographers: Gilles Bensimon, Aline Coquelle, Jean-Marie Del Moral, Patrick Demarchellier, Eshel Ezer, Aldo Fallai, Laziz Hamani, John Huba, Ron Kedmi, Ben Lam, Booz Lamir, Mike Reinhardt, George Silk, Joseph Sohm and the late Norman Parkinson; the agencies AKG, Corbis, Guetty Images, Optimum, Turnowsky, Yehoshua TBWA, Richard Anastasio from Sports Illustrated and the SBM, Monte-Carlo.